G000038868

L A R K

S T U D I O S E R I E S

Tables

LARK CRAFTS

An Imprint of
Sterling Publishing Co., Inc.
New York

Library of Congress Cataloging-in-Publication Data

Lark studio series : tables. -- 1st ed.
 p. cm.
 Includes index.
 ISBN 978-1-4547-0085-2 (pb-flexibound : alk. paper)
 1. Tables--History--21st century--Catalogs. 2. Studio furniture--History--21st century--Catalogs. I. Title: Tables.
 NK2740.L37 2011
 749'.3--dc22

2011007642

10 9 8 7 6 5 4 3 2 1

First Edition

SENIOR EDITOR
Linda Kopp

EDITOR
Julie Hale

ART DIRECTOR
Kristi Pfeffer

LAYOUT
Matt Shay

COVER DESIGNER
Kristi Pfeffer

Published by Lark Crafts, An Imprint of
Sterling Publishing Co., Inc.
387 Park Avenue South, New York, NY 10016

Text © 2011, Lark Crafts, an Imprint of Sterling Publishing Co., Inc.
Photography © 2011, Artist/Photographer

Distributed in Canada by Sterling Publishing,
c/o Canadian Manda Group, 165 Dufferin Street
Toronto, Ontario, Canada M6K 3H6

Distributed in the United Kingdom by GMC Distribution Services,
Castle Place, 166 High Street, Lewes, East Sussex, England BN7 1XU

Distributed in Australia by Capricorn Link (Australia) Pty Ltd.,
P.O. Box 704, Windsor, NSW 2756 Australia

FRONT COVER
Anne Bossert
Atomic Egg Side Table
PHOTO BY JOE MENDOZA

BACK COVER
Mark Del Guidice
Split Coffee Table
PHOTO BY CLEMENTS/HOWCROFT

PAGE 3
Alison J. McLennan
Yellow-Legged Table
PHOTO BY ARTIST

PAGE 4
Arnt Arntzen
Stardust Lounge Bar
PHOTO BY BRIAN K. SMITH

If you have questions or comments about this book, please contact:
LARK CRAFTS | 67 Broadway | Asheville, NC 28801 | 828-253-0467

Manufactured in China

ISBN 13: 978-1-4547-0085-2

For information about special sales, contact the Sterling Special Sales Department at
800-805-5489 or **specialsales@sterlingpub.com.**

For information about desk and examination copies available to college and university professors, requests must be submitted to academic@larkbooks.com. Our complete policy can be found at www.larkcrafts.com.

CONTENTS

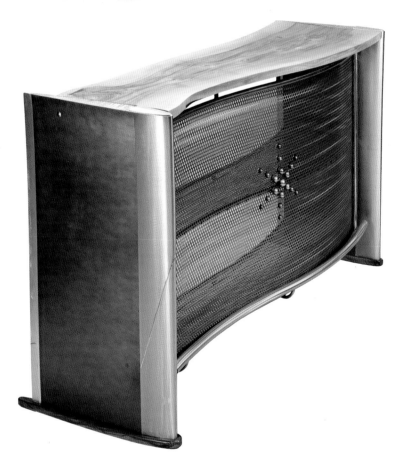

INTRODUCTION

The Lark Studio Series is designed to give you an insider's look at some of the most exciting work being made by artists today. The tables we've selected are fully functional, but they're also innovative works of art—fresh variations on a traditional form. In many of these delightful pieces, creativity overshadows utility in ways that push the boundaries of conventional furniture design. Using wood from around the world, as well as metal, stone, glass, and a range of found objects, the artists featured here bring a variety of perspectives and aesthetics to the creative process. Wonderfully diverse, this surprising collection is sure to change the way you think about furniture.

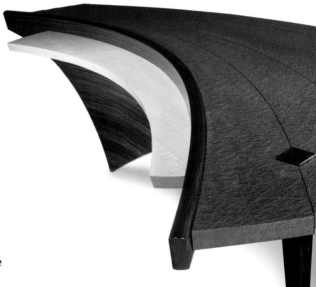

Michael C. Fortune

FAN COFFEE TABLE
15 x 78 x 30 inches (38.1 x 198.1 x 76.2 cm)

Bee's wing mahogany, Macassar ebony, curly maple

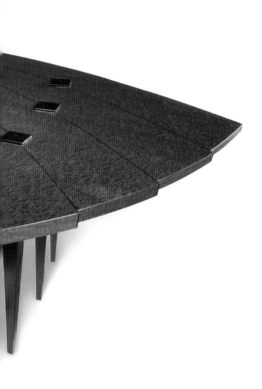

Richard Bronk

UNTITLED
18 x 36 x 36 inches (45.7 x 91.4 x 91.4 cm)

Cherry, various maples, spalted
maple, wenge, glass top

PHOTO BY WILLIAM LEMKE

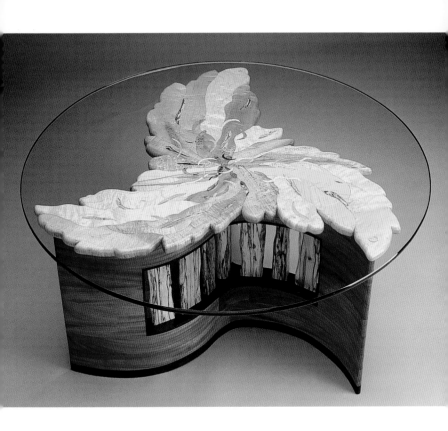

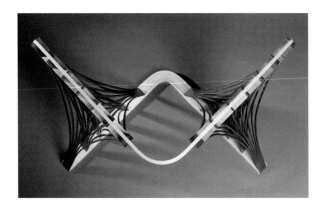

Seth Rolland

PARABOLA SIDE TABLE
22 x 40 x 21 inches (55.9 x 101.6 x 53.3 cm)

Walnut, ash, glass

PHOTOS BY FRANK ROSS

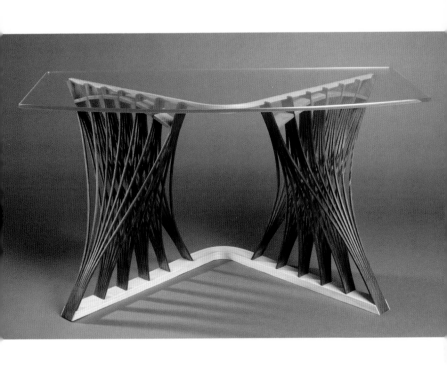

Paulus Wanrooij

OCEANA DEMILUNE
33 x 40 x 20 inches (83.8 x 101.6 x 50.8 cm)

Walnut, maple, sapele

PHOTO BY DENNIS GRIGGS

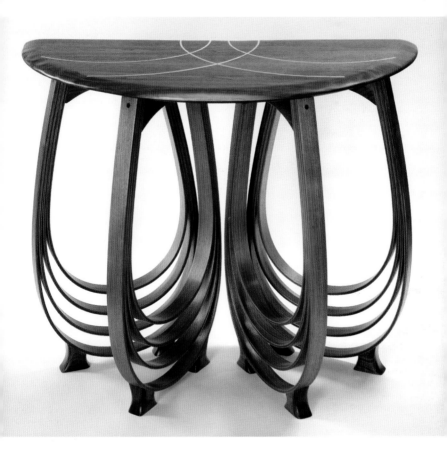

Seth Rolland

TSUBO COFFEE TABLE
17 x 55 x 27 inches (43.2 x 139.7 x 68.6 cm)

Salvaged mahogany, granite

PHOTO BY FRANK ROSS

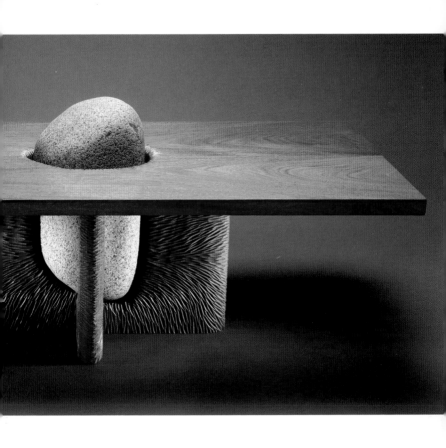

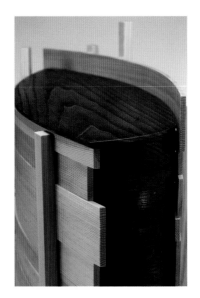

Matt T. Hutton

CORE SAMPLE #10
29 x 29 x 9 inches (73.7 x 73.7 x 22.9 cm)

Ash, fir, ebonized ash

PHOTOS BY JAY YORK

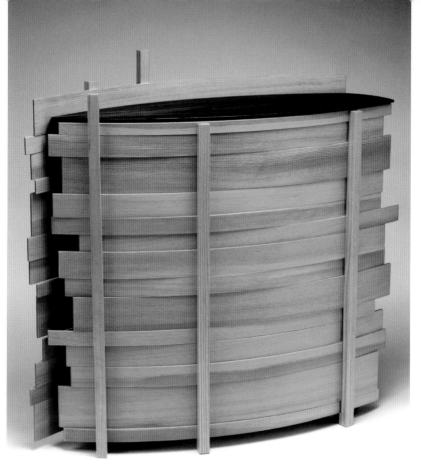

Alison J. McLennan

YELLOW-LEGGED TABLE

21 x 24 x 24 inches (53.3 x 61 x 61 cm)

Mahogany, walnut, lacewood, plywood,
fiberglass, lacquer, pigmented epoxy

PHOTO BY ARTIST

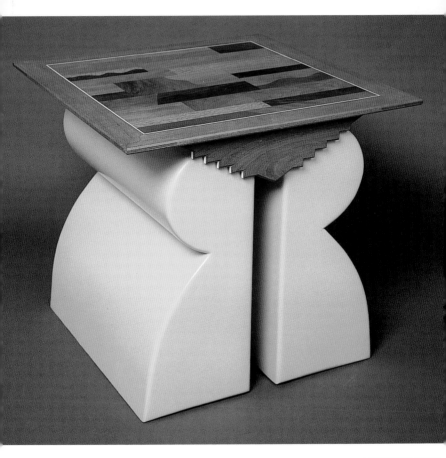

Mark S. Levin

VIVALDI LEAF HALL TABLE
30 x 54 x 26 inches (76.2 x 137.2 x 66 cm)

Solid walnut

PHOTO BY MARGOT GEIST

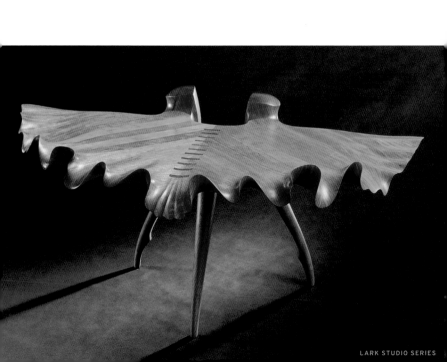

Glen Guarino

PURPLEHEART HALL TABLE
35 x 68 x 15 inches (88.9 x 172.7 x 38.1 cm)

Purpleheart

PHOTO BY RICH RUSSO PHOTOGRAPHY

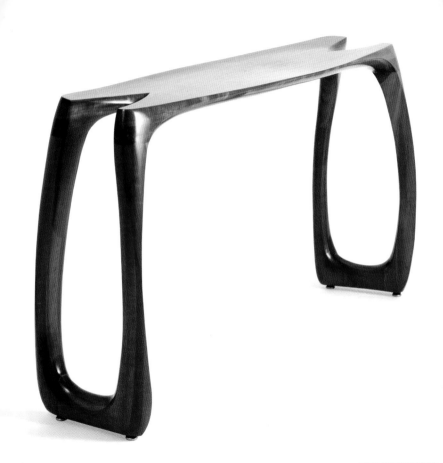

Tyson Atwell

SEISMIC V1

18 x 44 x 16 inches (45.7 x 111.8 x 40.6 cm)

Laminated plywood, maple veneer, sterling silver
aircraft cable, sterling silver hardware

PHOTO BY KALLAN NISHIMOTO

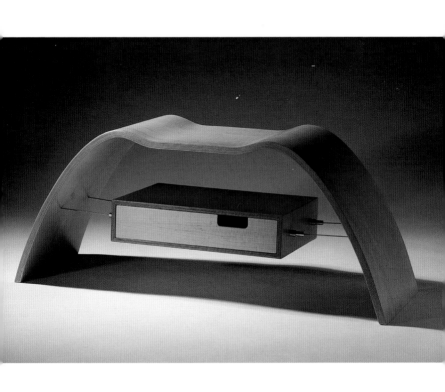

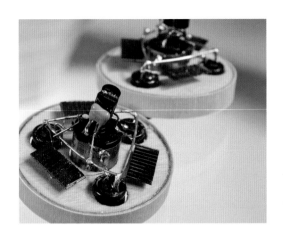

Matthew G. Hebert

VEHICLE #1: TABLE (FOR VALENTINO BRAITENBERG)
12 x 36 x 36 inches (30.5 x 91.4 x 91.4 cm)

Plywood, glass, electronics, milk paint

PHOTOS BY LARRY STANLEY

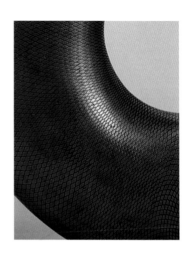

Graham Campbell

HILL DANCER
36 x 72 x 16 inches (91.4 x 182.9 x 40.6 cm)

Poplar, sycamore, walnut, paint

PHOTOS BY JOHN LUCAS

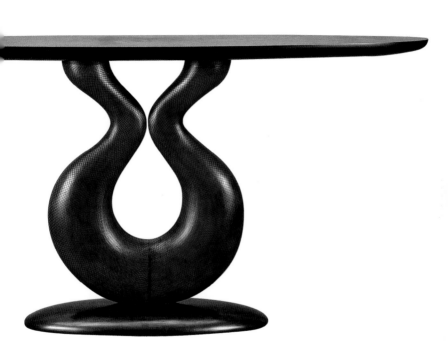

Patrick L. Dougherty

COSMOS TABLE

20 x 26½ inches (50.8 x 67.3 cm)

Wheel-formed earthenware clay, underglazes, glaze

PHOTO BY JAY BACHEMIN

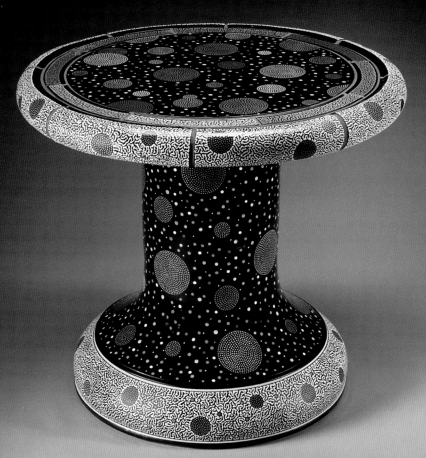

Michael C. Fortune

SIDE TABLE
30 x 76 x 12 inches (76.2 x 193 x 30.5 cm)

Cherry, Macassar ebony

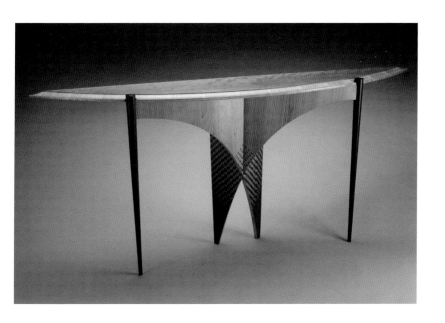

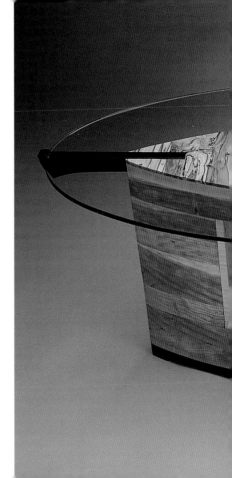

Richard Bronk

UNTITLED
18 x 48 x 24 inches (45.7 x 121.9 x 61 cm)

Cherry, spalted birch, curly
maple, wenge, glass top

PHOTO BY WILLIAM LEMKE

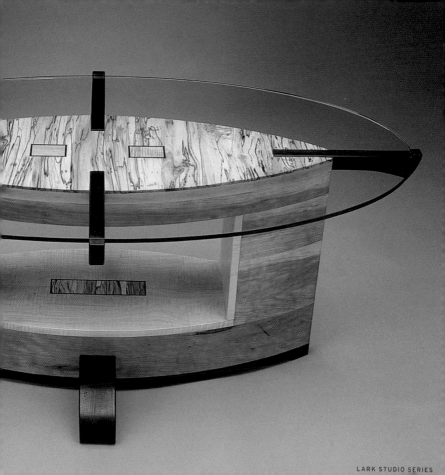

LARK STUDIO SERIES

Jennifer Costa

IT'S ABOUT TIME
18 x 36 x 20 inches (45.7 x 91.4 x 50.8 cm)

Cherry, purpleheart

PHOTO BY ARTIST

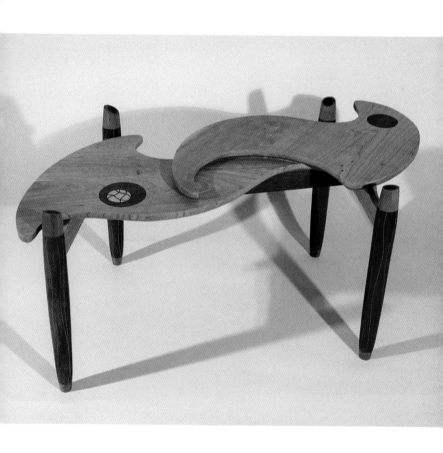

Jeff Wallin

TSUNAMI TABLE

17 x 48 x 16 inches (43.2 x 121.9 x 40.6 cm)

Mild steel, rust patina

PHOTO BY KEITH COTTON

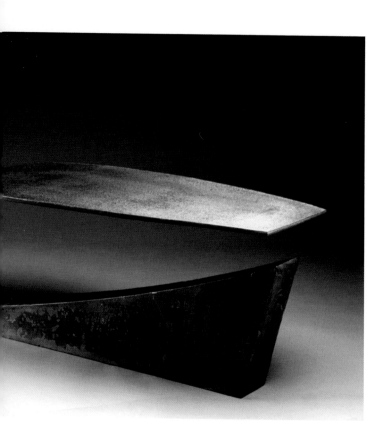

John Wiggers

CUFF LINK PEDESTAL TABLE
19 x 12 inches (48.3 x 30.5 cm)

Madero acero, birch plywood, polished stainless steel

PHOTO BY LORNE CHAPMAN

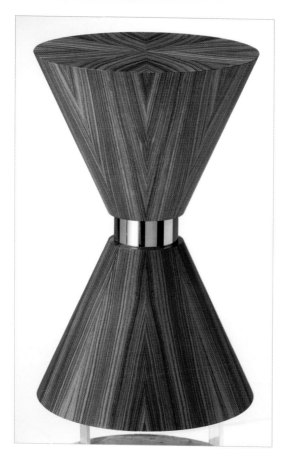

Mervyn L. Krivoshein

CLOTHESPIN TABLE
57 x 24 x 22 inches (144.8 x 61 x 55.9 cm)

Oak, spruce, mild steel, copper, Danish oil

PHOTO BY LOUISE FISHER

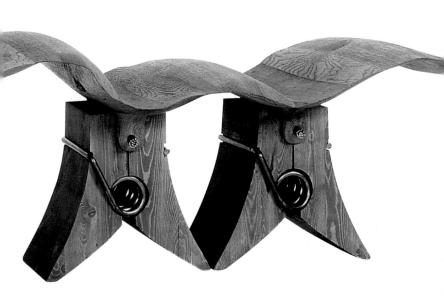

Alexandra Geske

COFFEE TABLE
18 x 48 x 22 inches (45.7 x 121.9 x 55.9 cm)

Medium-density fiberboard, paint, graphite

PHOTO BY TOM MILLS

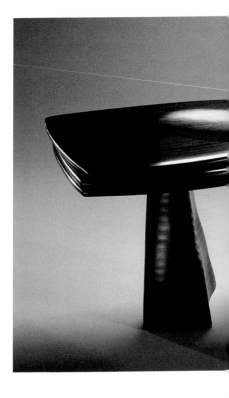

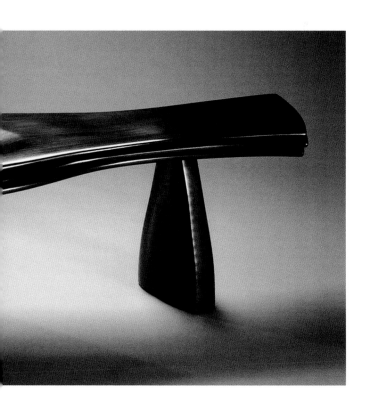

Heath Matysek-Snyder

MAHOGANY TWIST

16 x 48 x 16 inches (40.6 x 121.9 x 40.6 cm)

Mahogany, nails, glow-in-the-dark paint, birch plywood

PHOTOS BY LARRY STANLEY

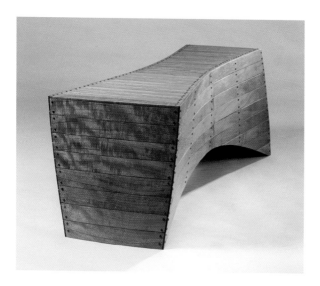

Kerry Vesper
Alisha Volotzky

WAVE

19 x 45 x 32 inches (48.3 x 114.3 x 81.3 cm)

Baltic birch, wenge, carved and painted glass

PHOTO BY GEORGE POST

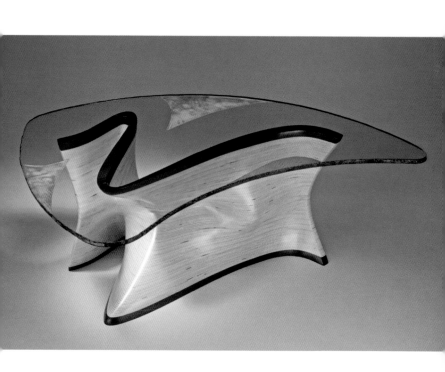

Kino Guérin

ESTRELLA TABLE
13 x 36 x 36 inches (33 x 91.4 x 91.4 cm)

Bloodwood and amazaque veneer, laminated plywood

PHOTO BY ELYSE BÉLANGER

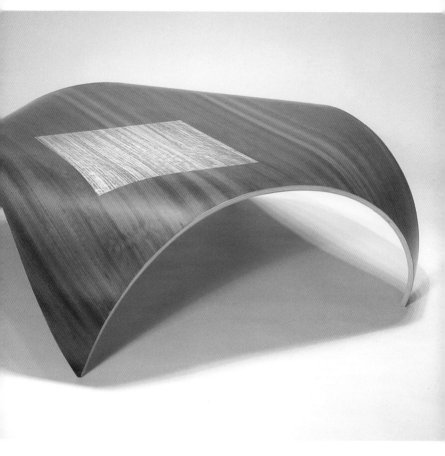

Gordon Galenza

REVERSIBLE ARRIVAL/DEPARTURE STATION
72 x 50 x 14 inches (182.9 x 127 x 35.6 cm)

Anigre, maple, paint, mirror

PHOTO BY JOHN DEAN PHOTOGRAPHS, INC.

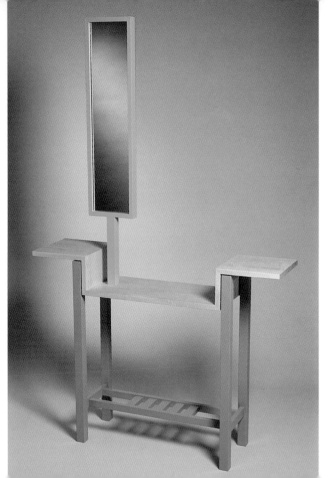

Arnt Arntzen

STARDUST LOUNGE BAR
40 x 72 x 30 inches (101.6 x 182.9 x 76.2 cm)

Walnut, tungsten aluminum helicopter rotor, steel, lacquer

PHOTO BY BRIAN K. SMITH

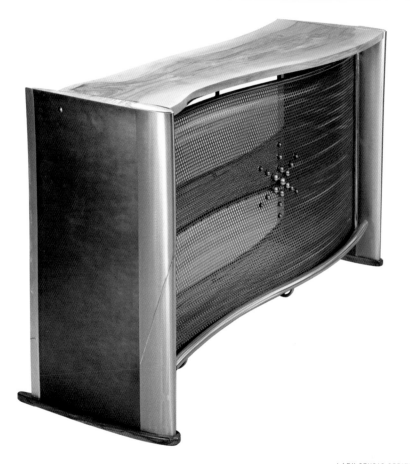

LARK STUDIO SERIES

Sylvie Rosenthal

BIRDIE SUITE

Table, 69 x 34 x 20 inches (175.3 x 86.4 x 50.8 cm);
Chair, 19$\frac{1}{2}$ x 17 x 15 inches (49.5 x 43.1 x 38.1 cm)

Mahogany, poplar, white oak, milk paint, steel, mixed media

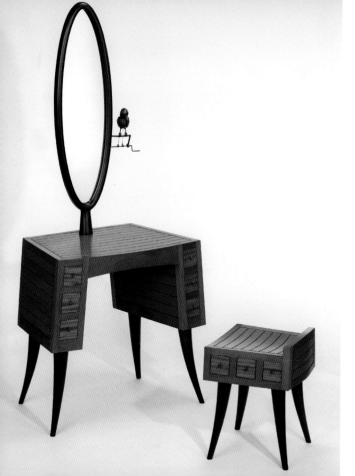

Stefan Furrer

SURFBOARD
30 x 55 x 34 inches (76.2 x 139.7 x 86.4 cm)

Maple, walnut, angle iron

PHOTO BY JOHN BIRCHARD

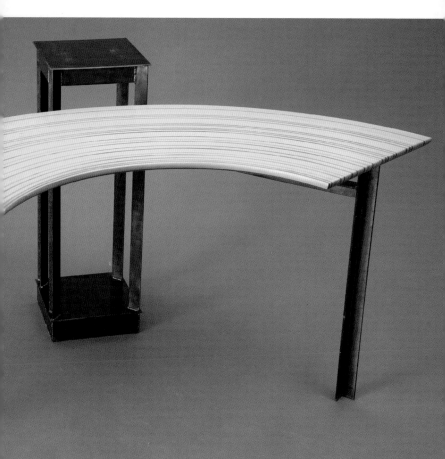

Floyd Gompf

HOMAGE TO FLW: COFFEE TABLE
20 x 35 x 18 inches (50.8 x 88.9 x 45.7 cm)

Found wood

PHOTO BY RICHARD HELLYER

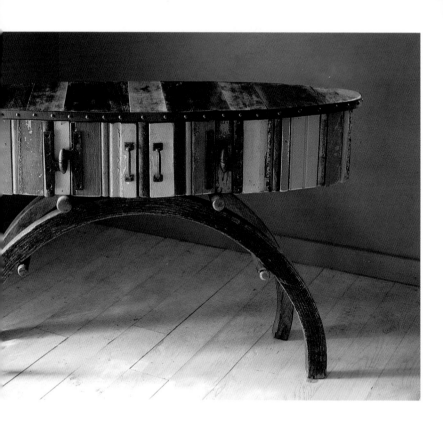

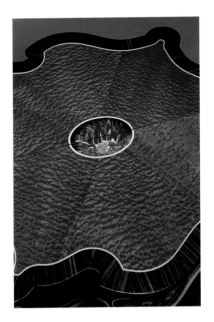

Alfred Sharp

CARD TABLE
30 x 34 x 17 inches (76.2 x 86.4 x 43.2 cm)

Macassar ebony, sapele, sycamore, poplar

PHOTOS BY JOHN LUCAS

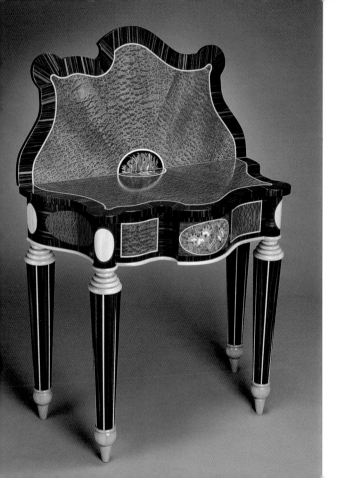

Seth Rolland

DREAMCATCHER HALL TABLE
36 x 54 x 15 inches (91.4 x 137.2 x 38.1 cm)

Ash, mahogany

PHOTO BY FRANK ROSS

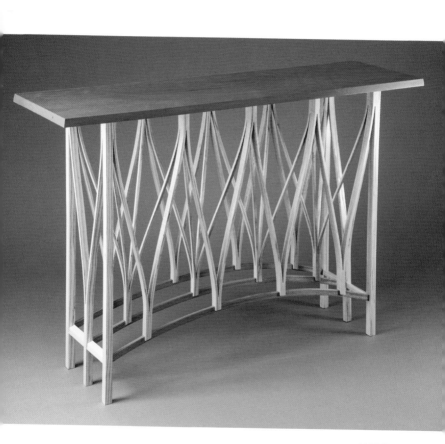

Mats Fogelvik

HIGH HEELS
24 x 24 x 24 inches (61 x 61 x 61 cm)

Koa, koa veneer, wenge

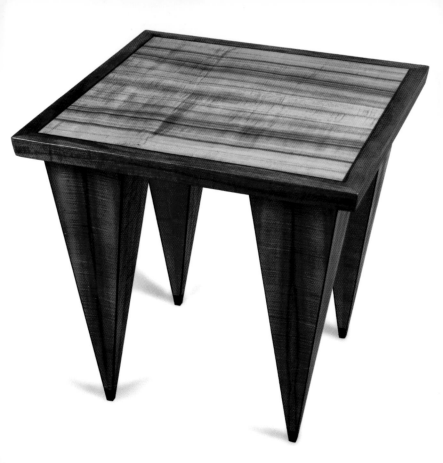

Leonard Fieber

SWEET STICKS SOFA TABLE

30 x 53 x 13½ inches (76.2 x 134.6 x 34.3 cm)

Aspen, maple, pine

PHOTO BY DAN WHITE

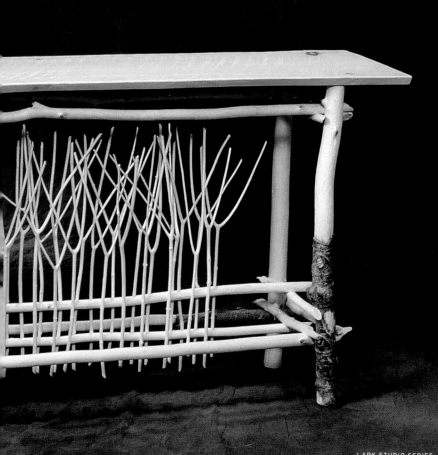

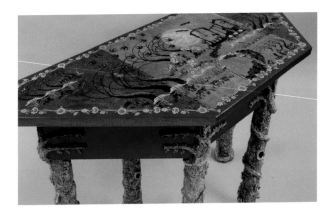

Natalie Wargin

WOODLAND DEMILUNE
45 x 19 x 30 inches (114.3 x 48.3 x 76.2 cm)

Newspaper, white glue, wire mesh, acrylic paints,
varnish, paper pulp, collaged images

PHOTOS BY PHILIP MROZINSKI

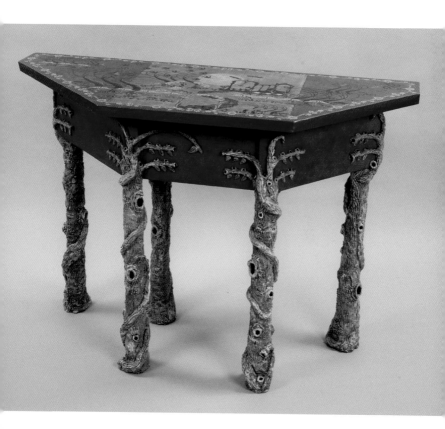

Chia-Wei Sun

BLOCK
8 x 7 x 18 inches (20.3 x 17.8 x 45.7 cm)

Poplar, red oak, glass

PHOTO BY WAYNE C. MOORE

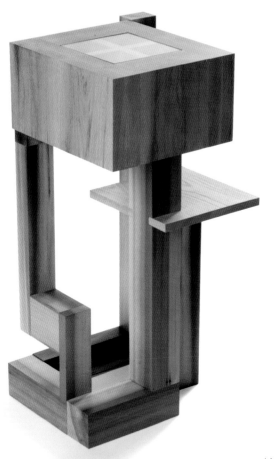

Donald H. Moss

ICE TABLE
31 x 35 x 23 inches (78.7 x 88.9 x 58.4 cm)

White birch, black grout, etched glass, wire

PHOTO BY SCOTT VAN SICKLIN

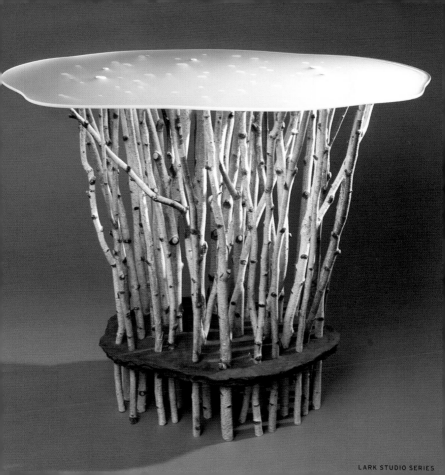

Floyd Gompf

WHEELED SIDE TABLE
29 x 18 x 13 inches (73.7 x 45.7 x 33 cm)

Found wood, found wheels

PHOTO BY RICHARD HELLYER

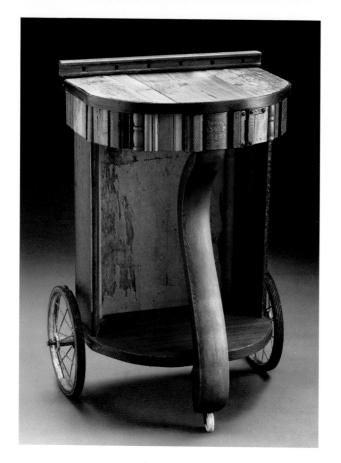

Mark Del Guidice

TABLE FOR ALL REASONS
30 x 33 x 33 inches (76.2 x 83.8 x 83.8 cm)

Bubinga, basswood, milk paint

PHOTO BY CLEMENTS/HOWCROFT

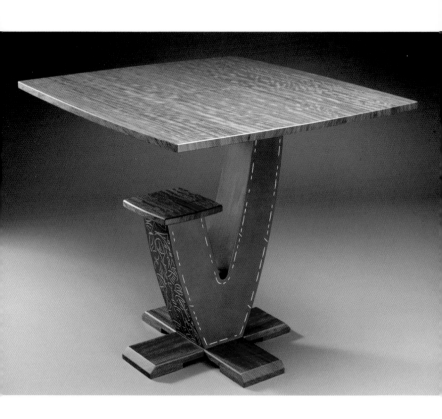

Gord Peteran

ASSEMBLED TABLE

40 x 48 x 18 inches (101.6 x 121.9 x 45.7 cm)

Found wood, brass

PHOTOS BY ELAINE BRODIE

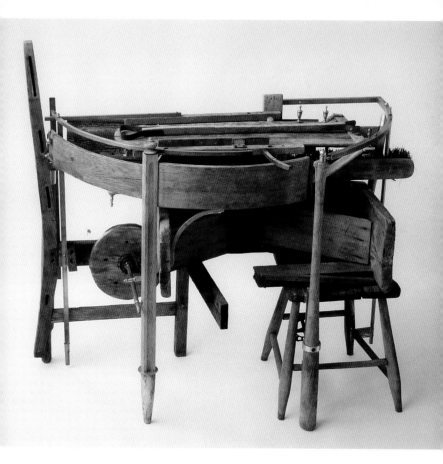

Graham Campbell

LURICKA
34 x 19 x 19 inches (86.4 x 48.3 x 48.3 cm)

Poplar, cherry, paint

PHOTO BY JOHN LUCAS

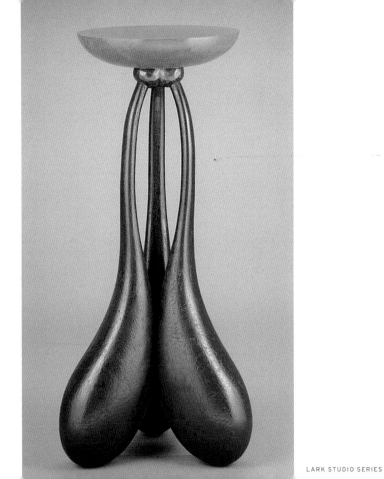

Mark S. Levin

PEAR COFFEE TABLE WITH DRAWER
16 x 43 x 30 inches (40.6 x 109.2 x 76.2 cm)

Australian lacewood, bubinga

PHOTO BY MARGOT GEIST

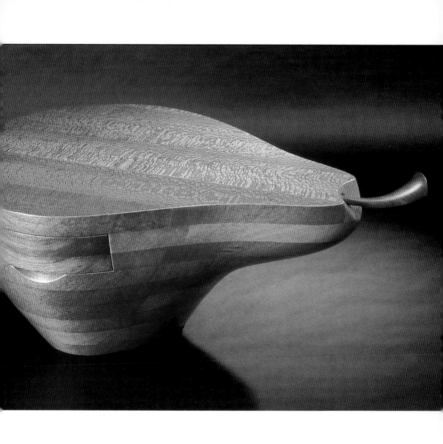

Dale Lewis

RUBY BEGONIA
36 x 26 x 25 inches (91.4 x 66 x 63.5 cm)

Curly maple, cherry, lacquer finish

PHOTO BY RALPH ANDERSON

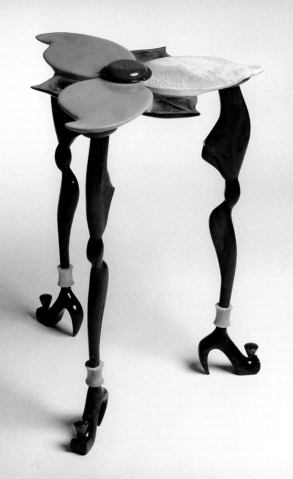

Craig Nutt

RADISH TABLE
29 x 24 x 24 inches (73.7 x 61 x 61 cm)

Bleached maple, oil paint

PHOTO BY JOHN LUCAS

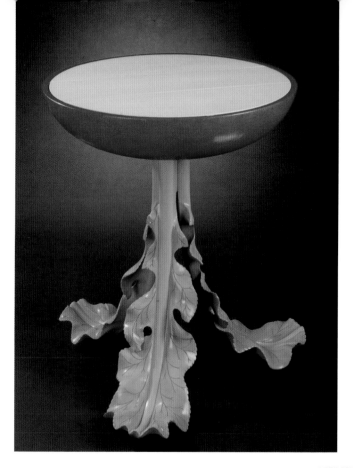

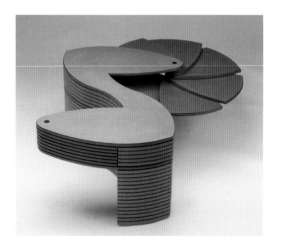

Jeremy J. Cox

CANTILEVER
19$\frac{1}{2}$ x 74 x 28 inches (49.5 x 188 x 71.1 cm)

Synthetic hardboard, medium-density fiberboard, aluminum rod, milk paint

PHOTOS BY ARTIST

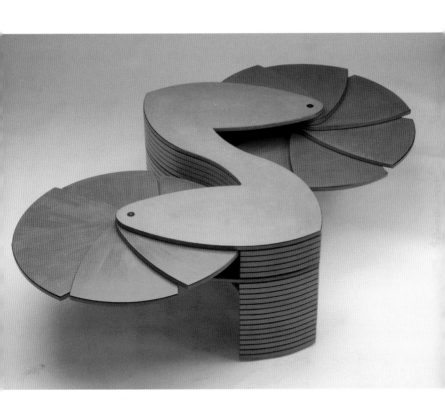

Kerry O. Furlani
David Hurwitz

NAUTILUS END TABLE

24 x 27 x 20 inches (61 x 68.6 x 50.8 cm)

Vermont green slate, Vermont sugar maple, steel plate

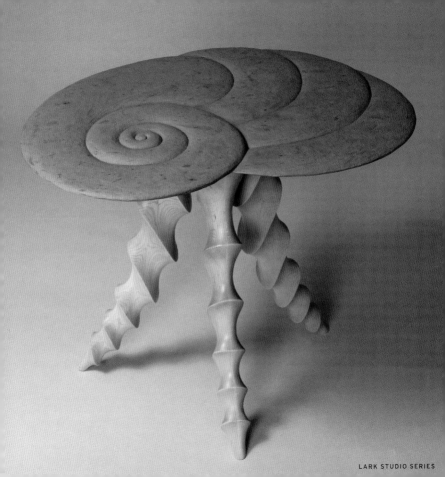

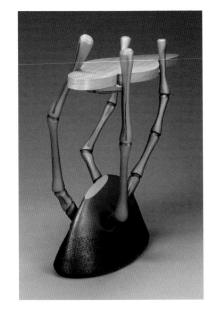

Brent Harrison Skidmore

TOP DOWN BOO

34 x 57 x 18 inches (86.4 x 144.8 x 45.7 cm)

Plane tree, poplar, steel, acrylic paints

PHOTOS BY DAVID RAMSEY

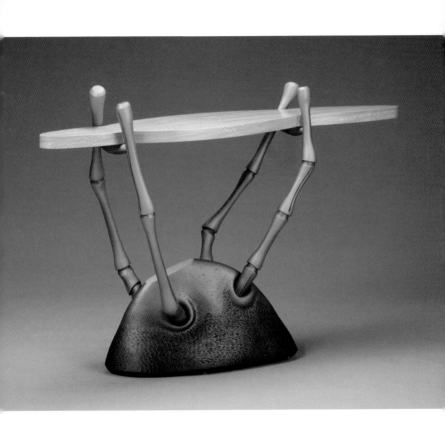

Dale Lewis

PURSUING THE ELUSIVE RED DOT
24 x 24 x 14 inches (61 x 61 x 35.6 cm)

Curly maple, ebony, bloodwood, lacquer finish

PHOTO BY ARTIST

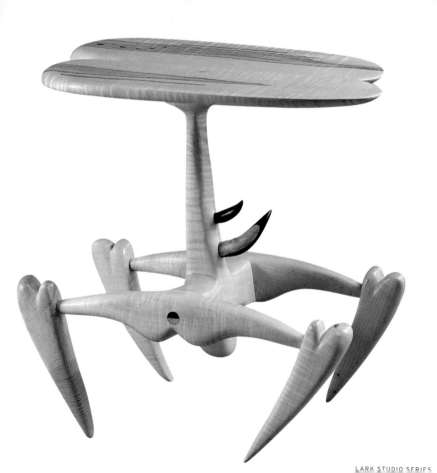

Brent Harrison Skidmore

LOW-SLUNG BOULDERS TABLE
17 x 53 x 24 inches (43.2 x 134.6 x 61 cm)

Ash, basswood, acrylic paint, glass

PHOTO BY DARLENE KACZMARCZYK

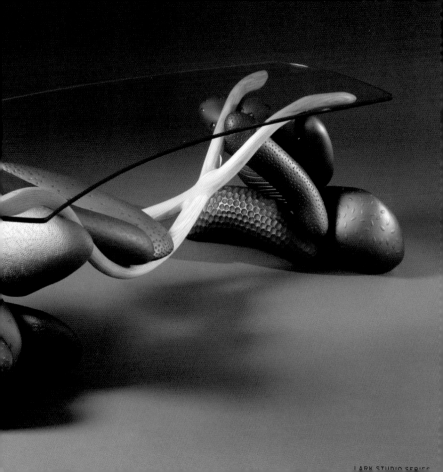

Gordon Galenza

MALCOLM TABLES
22 x 18 x 18 inches (55.9 x 45.7 x 45.7 cm)

Bubinga, sycamore, zebrano, anodized aluminum, glass

PHOTO BY JOHN DEAN PHOTOGRAPHS, INC.

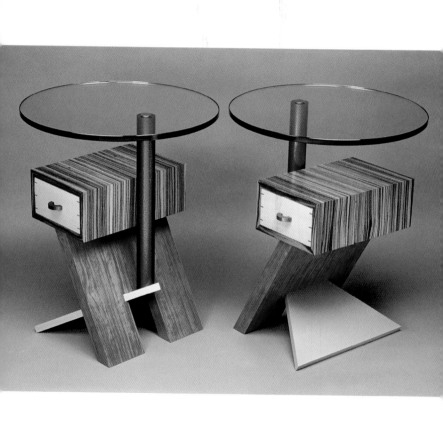

John McDermott

WHEELBARREL TABLE
17 x 24 x 65 inches (43.2 x 61 x 165.1 cm)

White oak, rubber tire, metal rim

PHOTO BY MARTIN FOX

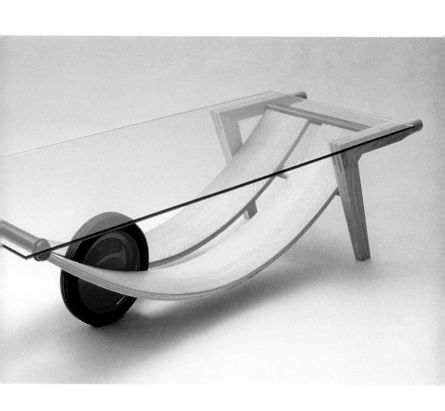

Boris Bally

RECTANGULAR TRANSIT TABLES

17 1/2 x 36 x 20 inches (44.5 x 91.4 x 50.8 cm)

Recycled aluminum traffic signs, recycled aluminum tube,
steel hardware, champagne corks

PHOTO BY ARTIST

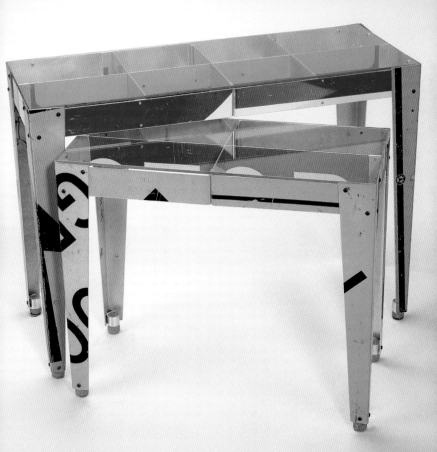

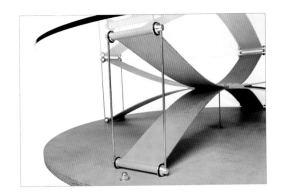

Mordechai Schleifer

THE STATIC WIND WING

15¾ x 47¼ inches (40 x 120 cm)

Toned plywood, stainless steel, glass

PHOTOS BY YOAV GURIN

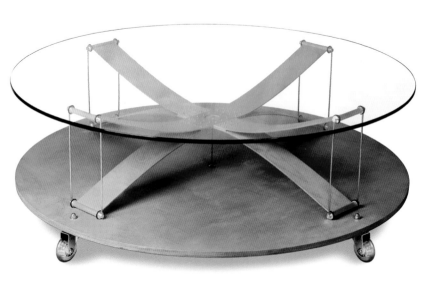

Stephen Hogbin

CLARITY
35 x 18 inches (88.9 x 45.7 cm)

Ebonized wood, maple, glass

PHOTO BY ARTIST

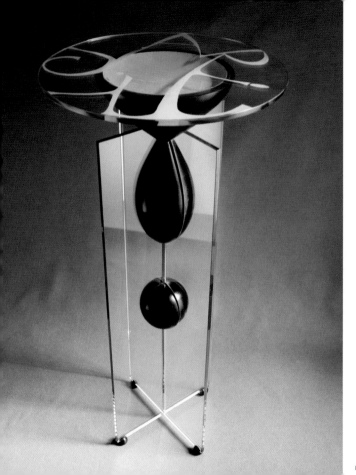

Jennifer E. Schwarz

GIBSON'S TABLE
15 x 56 x 48 inches (38.1 x 142.2 x 121.9 cm)

Alder, maple, medium-density fiberboard, colored lacquer, glass

PHOTO BY DAVID BROWNE

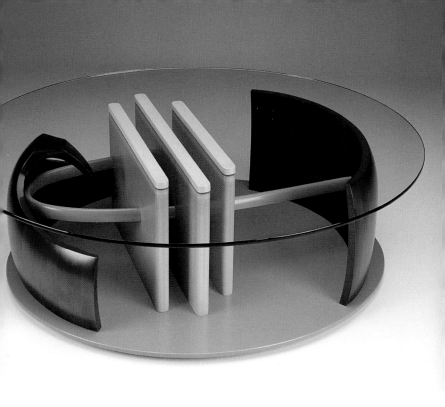

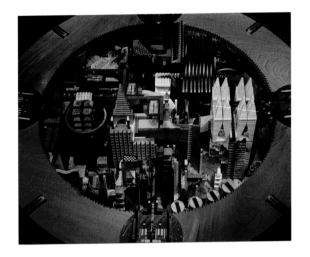

Po Shun Leong

CITY

16 x 60 inches (40.6 x 152.4 cm)

Mahogany, buckeye burl, cherry burl, bleached maple, pink ivory wood,
pau amarelo, narra, palm, ebony, bocote, koa, purpleheart, gold leaf

PHOTOS BY ARTIST

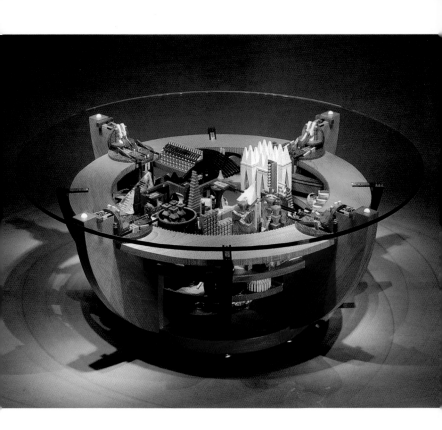

Alison J. McLennan

PURGATORY COFFEE TABLE

19½ x 46 x 24 inches (49.5 x 116.8 x 61 cm)

Plywood, fiberglass, lacquer, 23-karat gold leaf,
silver leaf, 23-karat gold-plated brass

PHOTO BY ARTIST

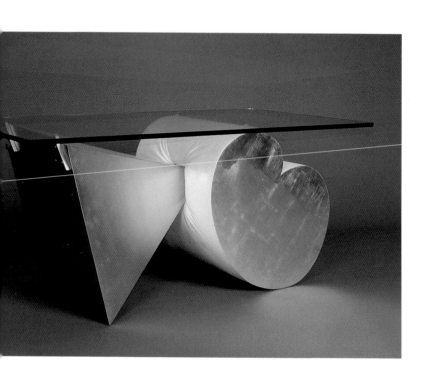

Michael Martell
Claudia Zeber-Martell

BISTRO TABLE
36 x 32 x 18 inches (91.4 x 81.3 x 45.7 cm)

Wheel-thrown earthenware clay, airbrushed underglazes,
gloss glaze finish, glass, brushed aluminum fittings

PHOTO BY JIM MARTIN

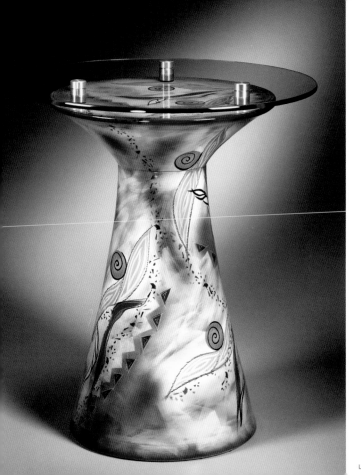

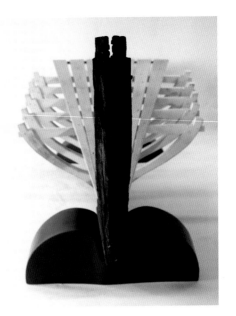

Stephen Whittlesey

DREAMBOAT

20 x 98 x 38 inches (50.8 x 248.9 x 96.5 cm)

Oak stem from old fishing boat, salvaged yellow pine

PHOTOS BY ARTIST

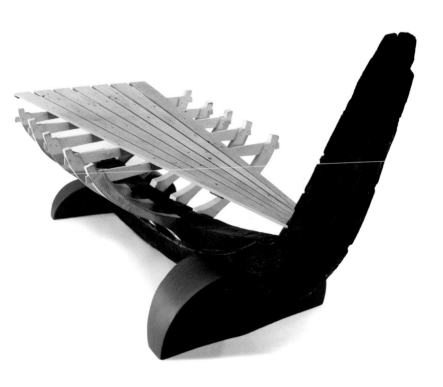

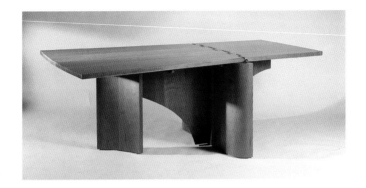

John Grew Sheridan

COOPERED, HINGED DINING TABLE
29 x 42 x 80 inches (73.7 x 106.7 x 203.2 cm)

Cherry, brass

PHOTOS BY SCHOPPLEIN.COM

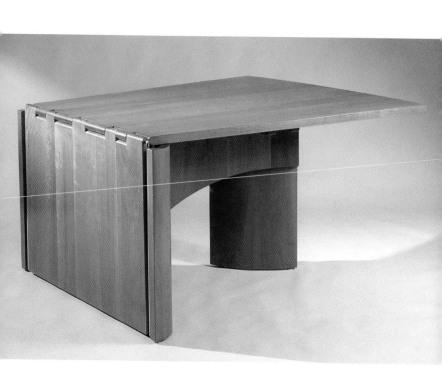

Bart Niswonger
Carl Schlerman

PEANUT TABLE
18 x 33 x 19 inches (45.7 x 83.8 x 48.3 cm)

Ash, ebonized ash, dye, catalyzed urethane

PHOTO BY ARTIST

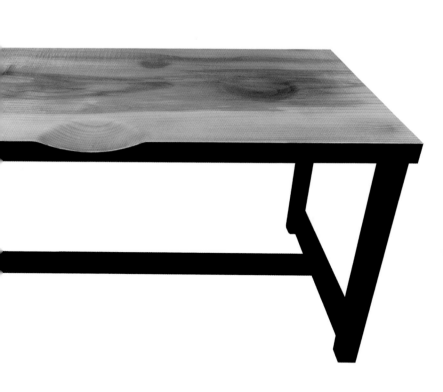

LARK STUDIO SERIES

Steve Mullenbach

UNTITLED
16 x 41 x 20 inches (40.6 x 104.1 x 50.8 cm)

Fiberglass, paint, maple, glass

PHOTO BY LUKE BERHOW AND ARTIST

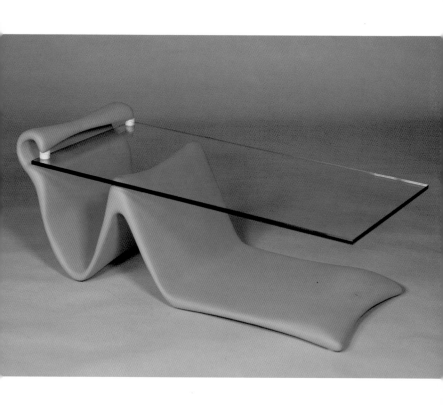

Seth Rolland

NORTH BEACH HALL TABLE
32 x 61 x 15 inches (81.3 x 154.9 x 38.1 cm)

European beech, natural stone

PHOTO BY FRANK ROSS

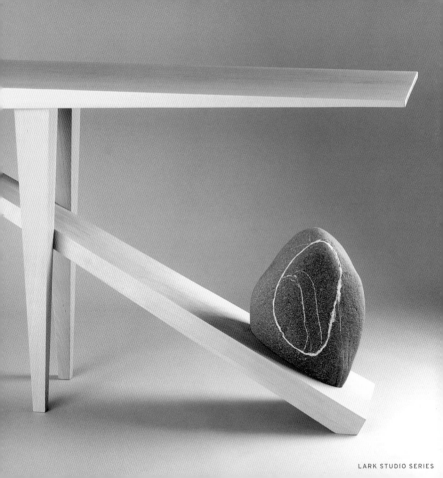

Jan Huling

UNTITLED

23 x 19½ x 20½ inches (58.4 x 49.5 x 52.1 cm)

Wood, glass, beads, ball-chain, gems, photograph

PHOTOS BY PHIL HULING

Richard Bronk

UNTITLED
31 x 47 x 17 inches (78.7 x 119.4 x 43.2 cm)

Cherry, curly maple, spalted birch, wenge

PHOTO BY WILLIAM LEMKE

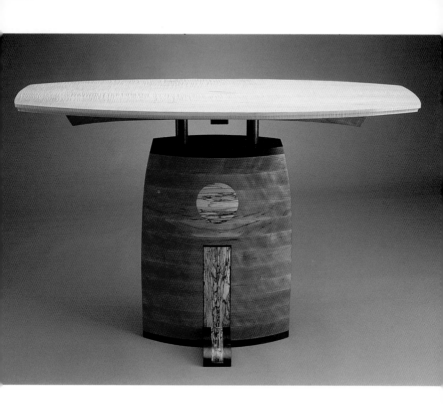

Chris Bowman

HEY SERIES #4
25 x 20 x 8 inches (63.5 x 50.8 x 20.3 cm)

Mahogany, poplar, birch, milk paint

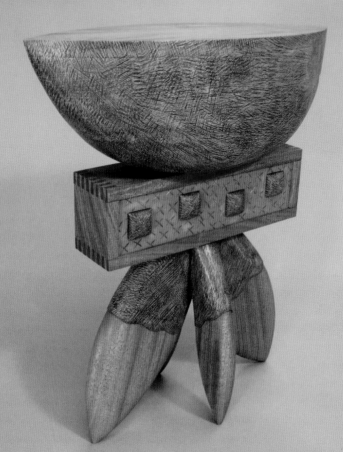

Mark Del Guidice

SPLIT COFFEE TABLE
18 x 60 x 24 inches (45.7 x 152.4 x 61 cm)

Mahogany, curly maple,
medium-density fiberboard, milk paint

PHOTO BY CLEMENTS/HOWCROFT

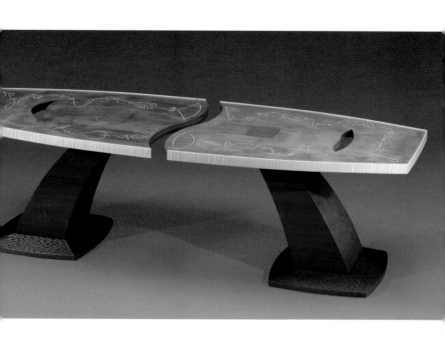

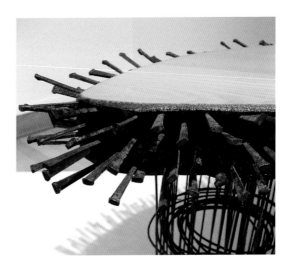

Steven T. Samson

AFRICAN NAIL FETISH COFFEE TABLE
54 x 36 inches (137.2 x 91.4 cm)

Birch, oil paint, nails, steel mesh

PHOTOS BY JEFFREY L. MEEUWSEN

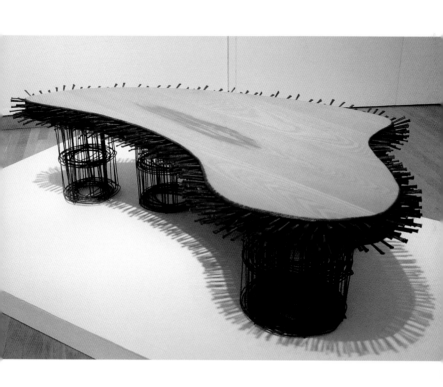

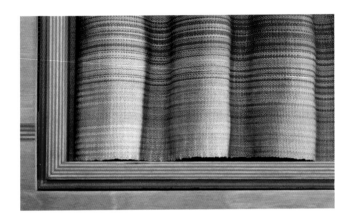

Anne Bossert

ATOMIC EGG SIDE TABLE
23¾ x 32 x 22 inches (60.3 x 81.3 x 55.9 cm)

Baltic beech plywood, dyed hand-woven cotton cloth, glass

PHOTOS BY JOE MENDOZA

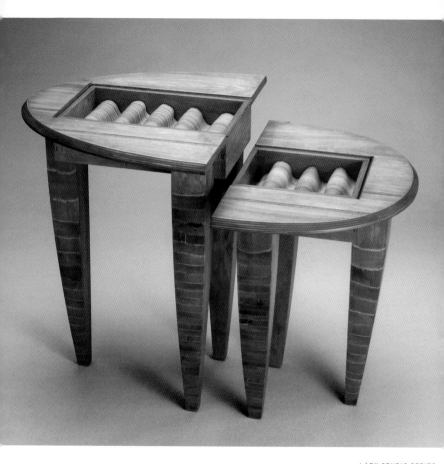

Richard Prisco

SYNCHRONIZED SWIMMING

15 x 52 inches (38.1 x 132.1 cm)

Mahogany, polished aluminum

PHOTOS BY JOSEPH BYRD

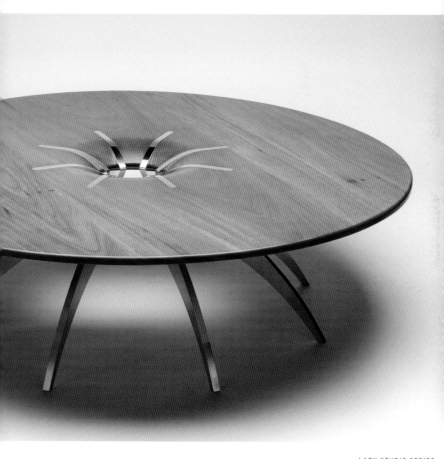

Lepo

UNTITLED
38 x 28 x 48 inches (96.5 x 71.1 x 121.9 cm)

Cherry, maple, cocobolo, acrylic

PHOTO BY MICHAEL J. AYERS

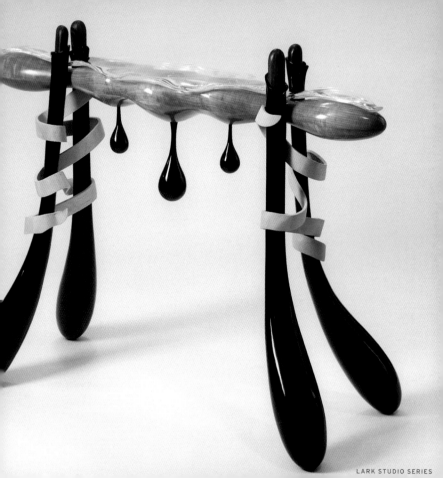

Charles B. Cobb

WHITE MESA SIDE TABLE

36 x 56 x 20 inches (91.4 x 142.2 x 50.8 cm)

Acacia, ebony, alpa veneer, medium-density fiberboard,
latex paint, black lacquer, orange safety paint

PHOTO BY HAP SAKWA

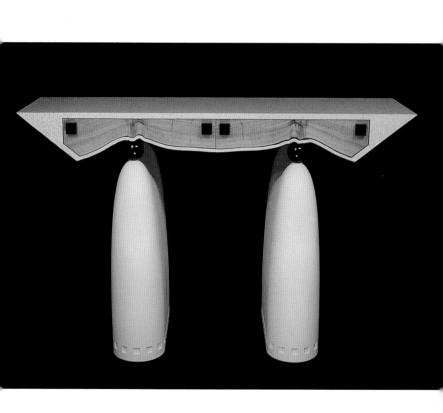

Michael Gloor

BOT TABLE
18 x 18 x 54 inches (45.7 x 45.7 x 137.2 cm)

Walnut, Douglas fir

PHOTO BY DAVID GILSTEIN

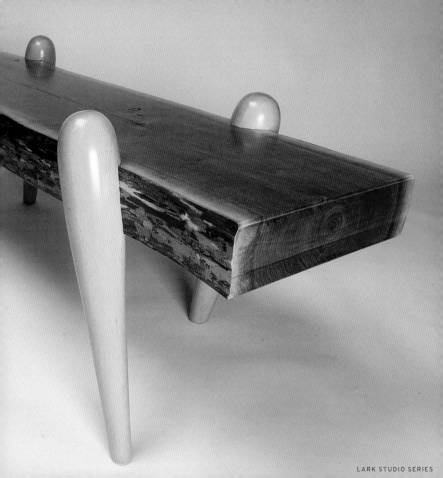

Brian M. Condran

CRESCENT MARBLE TABLE

34½ x 73 x 16 inches (87.6 x 185.4 x 40.6 cm)

Black walnut, Mendocino cypress,
verde antique select marble, patinated brass

PHOTO BY ARTIST

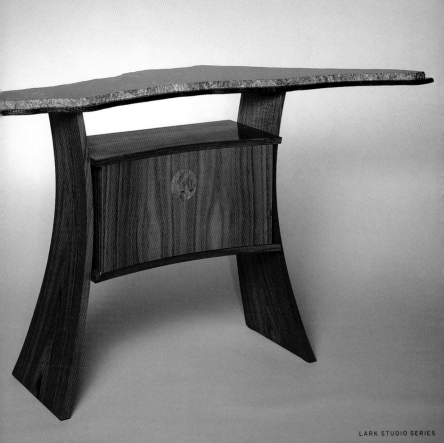

Paul M. Minniti

THE EXECUTIVE
34 x 68 x 14 inches (86.4 x 172.7 x 35.6 cm)

Mahogany, pomele sapele, ebonized mahogany, aluminum

PHOTO BY ROCHESTER INSTITUTE OF TECHNOLOGY PHOTOGRAPHY

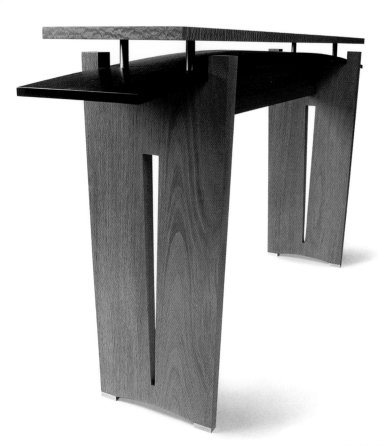

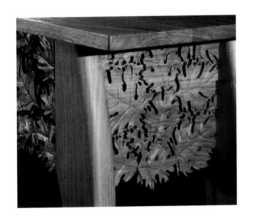

Pat Morrow

LEAF TABLE
32 x 52 x 14 inches (81.3 x 132.1 x 35.6 cm)

Butternut

PHOTOS BY TOBY THREADGILL

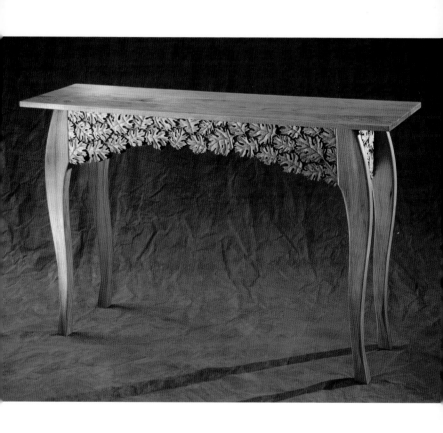

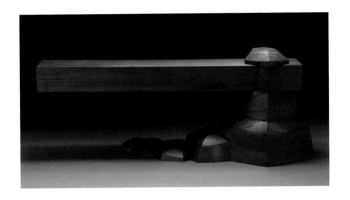

James P. McNabb

THREE-DRAWER TABLE
53 x 23 x 21 inches (134.6 x 58.4 x 53.3 cm)

Mahogany, steel

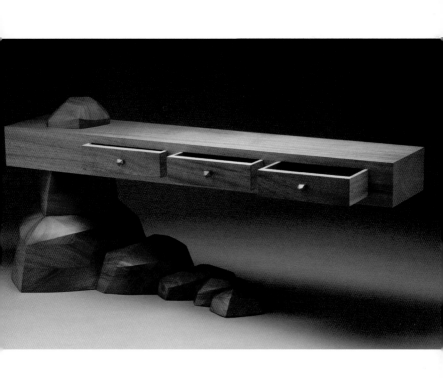

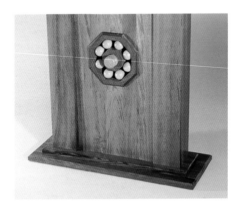

Richard Vaughan

LEONARDO BOARDROOM TABLE

28¾ x 165 x 59 inches (73 x 420 x 150 cm)

Tasmanian blackwood, silver ash,
 Australian rosewood, coachwood, hoop pine

PHOTOS BY GREG PIPER

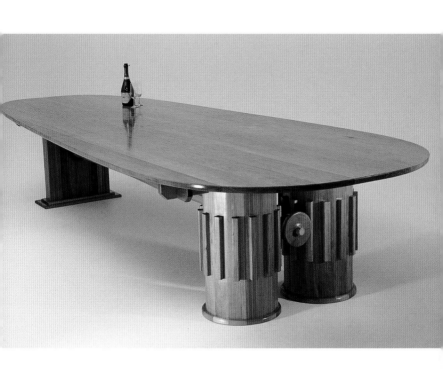

Mark Sfirri

WALKING TABLE
24 x 16 x 24 inches (61 x 40.6 x 61 cm)

Curly maple, mahogany

PHOTO BY ARTIST

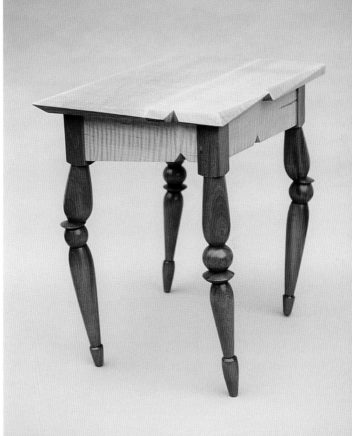

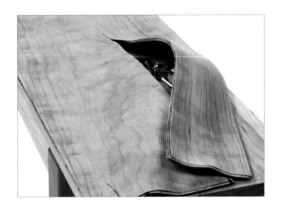

Farida A. Al Rashaid

I CAN'T FIND MY KEYS
32 x 43 x 13 inches (81.3 x 109.2 x 33 cm)

Wood, cherry, keys

PHOTOS BY TAYLOR DABNEY

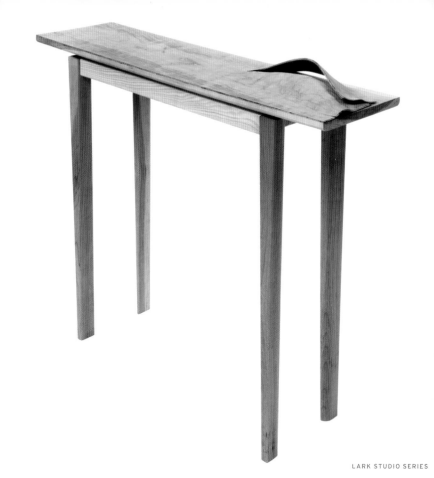

Chris Martin

IN BALANCE
21 x 29 x 22 inches (53.3 x 73.7 x 55.9 cm)

Reclaimed redwood, concrete, steel, brass plumb bob

PHOTO BY GEORGE ENSLEY

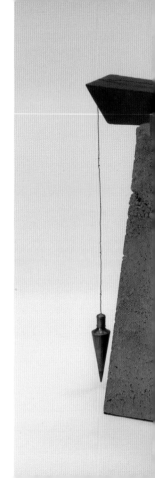

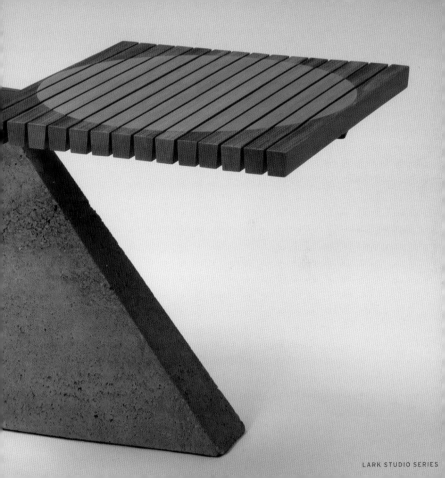

Arnold d'Epagnier

WRITING TABLE
30 x 54 x 22 inches (76.2 x 137.2 x 55.9 cm)

Bubinga, ebony

PHOTO BY MICHAEL LATIL

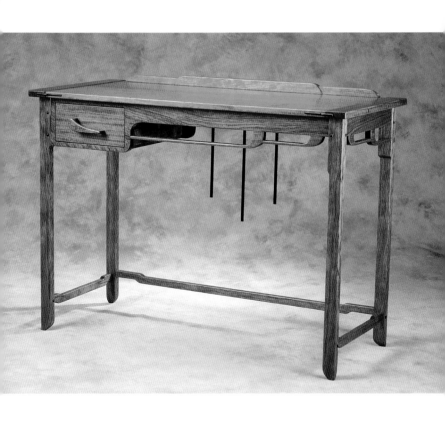

Roger Heitzman

DINING TABLE
29 x 40 x 84 inches (73.7 x 101.6 x 213.4 cm)

Mahogany, wenge

PHOTO BY ARTIST

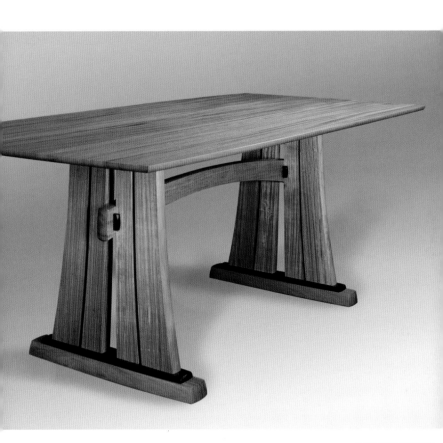

Todd Ouwehand

LO COFFEE TABLE
14 x 60 x 40 inches (35.6 x 152.4 x 101.6 cm)

Maple, quilted maple, wenge

PHOTO BY ALAN TOMLINSON

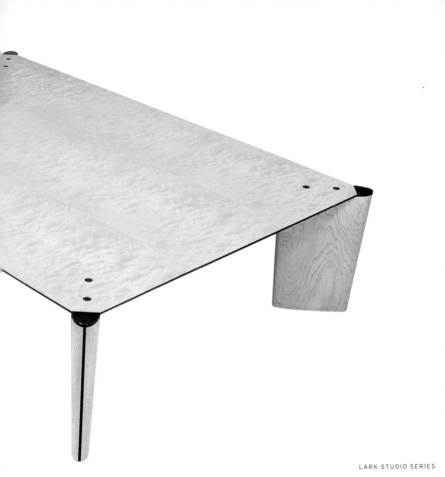

Brian A. Hubel

BUTTERFLY

30 x 108 x 40 inches (76.2 x 274.3 x 101.6 cm)

Mahogany, wenge

PHOTO BY DON JONES

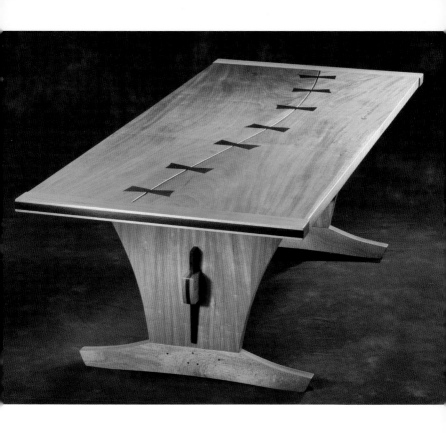

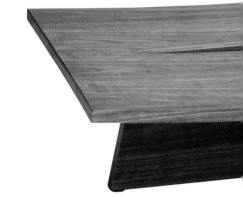

John Quan

SAN COFFEE TABLE

$8^{1}/_{2}$ x $35^{7}/_{16}$ x $23^{5}/_{8}$ inches (21.5 x 90 x 60 cm)

American walnut veneer, medium-density fiberboard, plywood, furniture wax

PHOTO BY GRANT HANCOCK

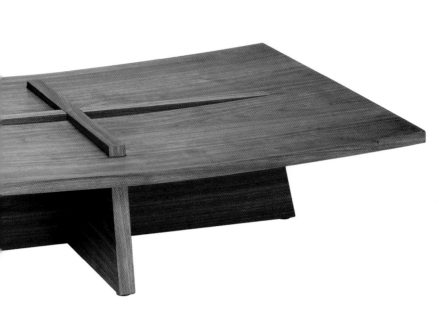

Phillip Mann

LODORE CANYON TABLE
16 x 18 x 48 inches (40.6 x 45.7 x 121.9 cm)

Honduran mahogany

PHOTOS BY JIM KREBS

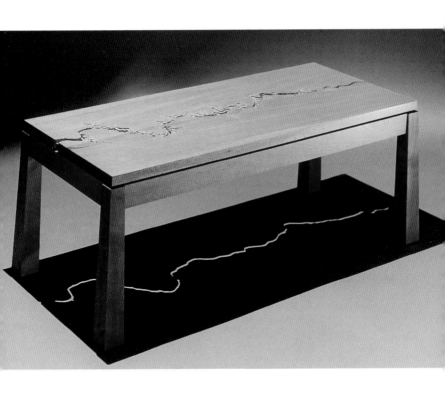

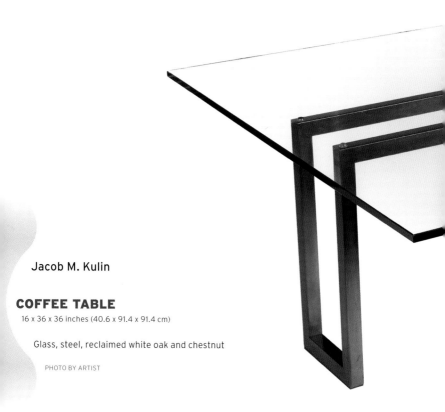

Jacob M. Kulin

COFFEE TABLE
16 x 36 x 36 inches (40.6 x 91.4 x 91.4 cm)

Glass, steel, reclaimed white oak and chestnut

PHOTO BY ARTIST

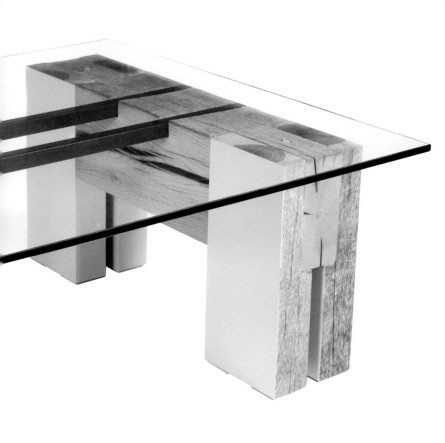

Bart Niswonger

BEDSIDE TABLES

21 x 21 x 21 inches (53.3 x 53.3 x 53.3 cm)

Ash, dye, catalyzed urethane, cast urethane

PHOTOS BY ARTIST

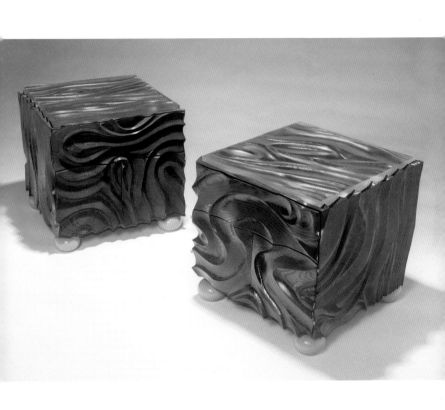

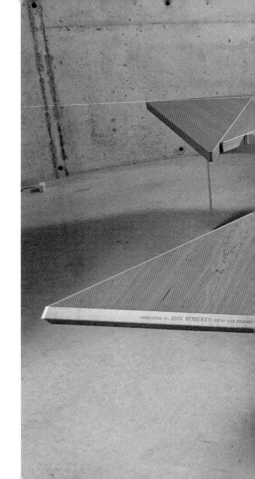

Michael C. Fortune

CONFERENCE TABLE
29 x 168 inches (73.7 x 426.7 cm)

Cherry, aluminum, hollow core

PHOTO BY ARTIST

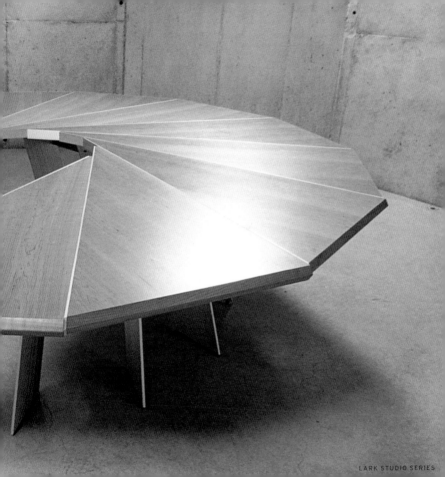

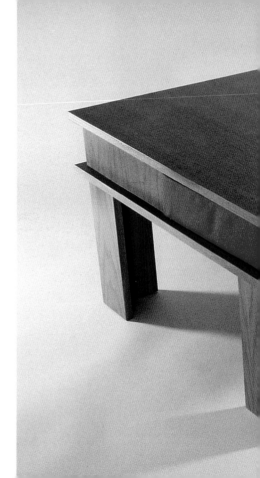

Kevin-Louis Barton

MONDRIAN II TABLE
18 x 46 x 30 inches (45.7 x 116.8 x 76.2 cm)

Walnut ply, fabric, foam, fiberfill

PHOTO BY ARTIST

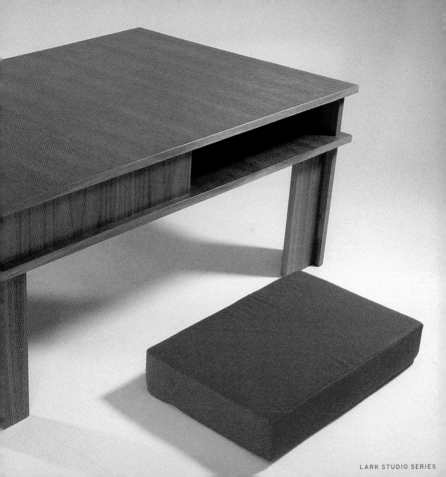

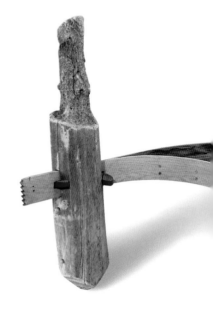

Stephen Whittlesey

EDDY

19 x 72 x 34 inches (48.3 x 182.9 x 86.4 cm)

Driftwood, salvaged oak, chestnut

PHOTO BY ARTIST

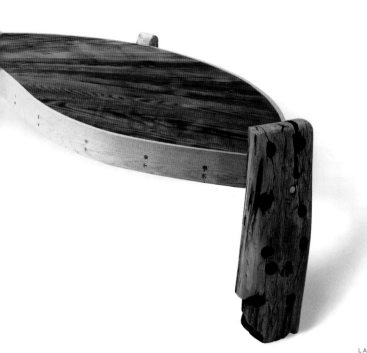

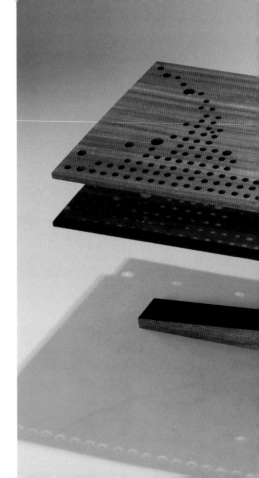

Ryan P. Seiler

PIERCED COFFEE TABLE
16¾ x 47 x 18 inches (42.5 x 119.4 x 45.7 cm)

Mahogany, milk paint, linseed oil

PHOTO BY GEORGE ENSLEY

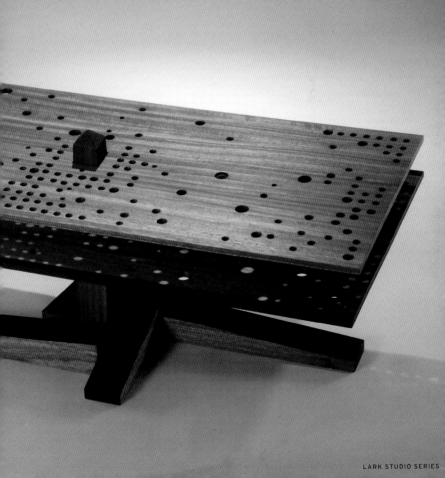

Wayne J. Petrie

OUT OF THE FOREST
19^{11}/$_{16}$ x 19^{11}/$_{16}$ x 19^{11}/$_{16}$ inches (50 x 50 x 50 cm)

Australian red cedar

PHOTO BY DAVID SANDISON

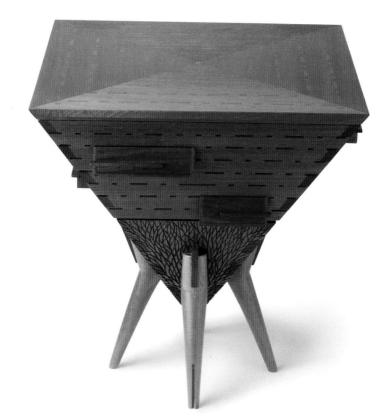

Frederick Puksta

VISITORS' OCCASIONAL NESTING TABLES
20 x 16 x 19 inches (50.8 x 40.6 x 48.3 cm)

Composite board, steel, copper, plastic, paint

PHOTO BY ARTIST

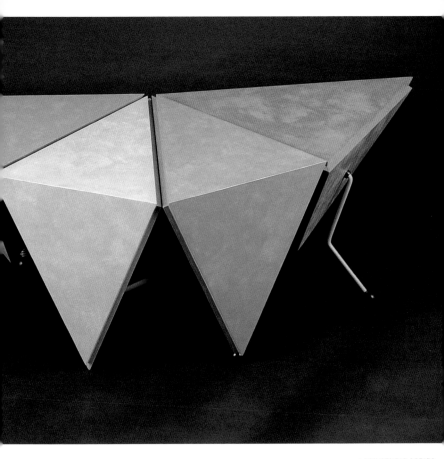

Wells Mason

BIG WHITE LITTLE RED
Tallest, 22 x 14 x 14 inches (55.9 x 35.6 x 35.6 cm)

Medium-density fiberboard, lacquer

PHOTO BY JIM TOBAC

Marcus C. Papay

LINEAR DISCONTINUITY
19 x 60 inches (48.3 x 152.4 cm)

Hard maple, steel

PHOTOS BY LARRY STANLEY

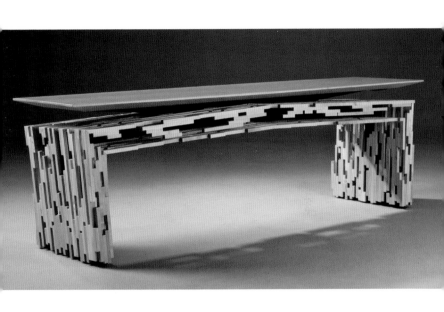

Sabine Gertraud Rasp

UNTITLED

32½ x 74½ x 74½ inches (82.6 x 189.2 x 189.2 cm)

Maple, glass, silver leaf

PHOTO BY KAREN BENGALL

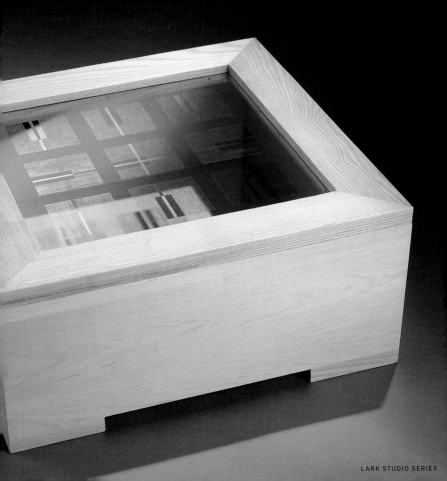

Janice C. Smith

HONEY
21 x 48 x 20 inches (53.3 x 121.9 x 50.8 cm)

Honeycomb panel made from recycled paper, ash

PHOTO BY JANICE SMITH

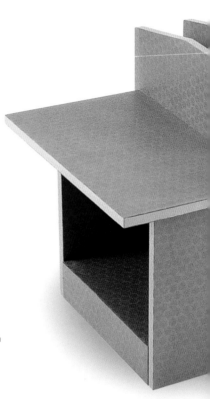

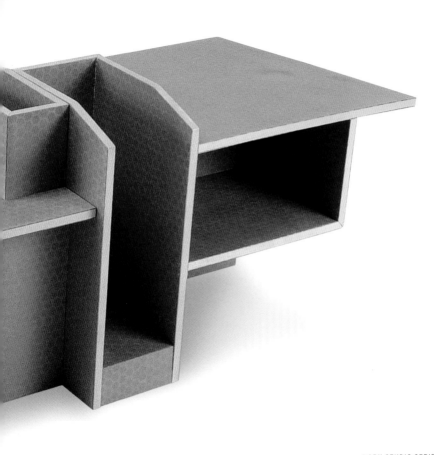

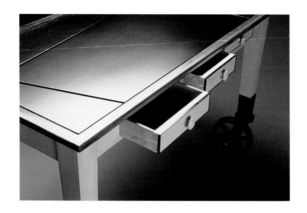

Sylvie Rosenthal

RACING DESK
30 x 48 x 24 inches (76.2 x 121.9 x 61 cm)

Maple, mahogany, poplar, oak, steel, dye, milk paint

PHOTOS BY ARTIST

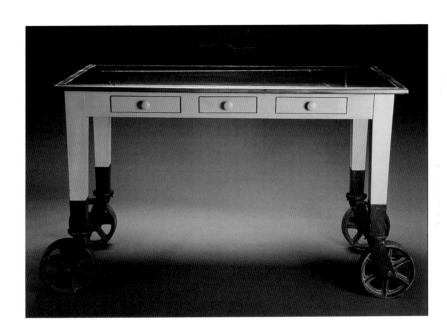

ARTIST INDEX

Enjoy more of the books in the
LARK STUDIO SERIES

Ceramic Sculptures

Handmade Dolls

Art Tiles

Handmade Books

Tables

Earrings

Chairs

Pendants